Lassen
❋ PEACEFUL REFLECTIONS ❋

ENFANTINO PUBLISHING
A Division of Enfantino Inc.

Published to the book trade by
WHITE STAG PRESS
a division of
PUBLISHERS DESIGN GROUP, INC.
ROSEVILLE, CALIFORNIA

© 2008 Enfantino Publishing
All rights reserved. No part of this book or any of the images, logos, or designs, may be reproduced or transmitted in any form or by any means, electronic or mechanical, including photocopying, recording, or by an information storage and retrieval system except by a reviewer who may quote brief passages in a review to be printed in a magazine, newspaper, or on the Web, without permission in writing from the publisher.

© 2008 Original paintings and artwork Christian Riese Lassen. All rights reserved.

© 2008 Original writings and reflections Carol Louise Lassen. All rights reserved.

Lassen: Peaceful Reflections is based on a previously published book titled *Tranquil Moments*, La Vie De Mer Publishing, Maui, 2002 (ISBN: 1879529262)

ISBN 13: 9780979258336

LIBRARY OF CONGRESS CONTROL: 2007931525

Original creative concept: Enfantino Publishing

Lassen: Peaceful Reflections
is a production of, and owned by
ENFANTINO PUBLISHING
a division of
Enfantino, Inc.
Cupertino, California
1-800-631-7506

Published to the book trade by
White Stag Press
a division of
Publishers Design Group, Inc.
Roseville, California
1.800.587.6666

Printed in China

Contents

1 The Door
2 The Secret Place
3 The Gift
4 The Mystical Marriage
5 Because of You
6 My Humble Prayer
7 His Angels Rejoice
8 Wedded Bliss
9 His Presence is Mighty
10 Our Creator
11 I Hunger
12 The Eternal Now
13 Beckoning Light
14 Knowing the Truth
15 Divine Presence
16 The Path to the Kingdom
17 Glory be to God
18 My Prayer
19 My Reward
20 God's Promise
21 Living Waters of Love
22 Trust
23 The Still Small Voice
24 The Resurrection
25 Love One Another

A Joy to Behold 26
Wings of Love 27
The Shelter of His Love 28
The One 29
Surrender 30
Choose This Day 31
His Temple Within 32
Angel Thoughts 33
Thank You, God 34
Life as Spirit 35
Reality 36
Flying with Angels 37
I Am Love 38
God in Action 39
God's Will 40
Set Free 41
His Image and Likeness 42
Letting Go 43
God's Touch 44
Our Eternal Life 45
Thank You, Father 46
The Truth of Being 47
God's Everlasting Kingdom 48
The Fourth Dimension 49

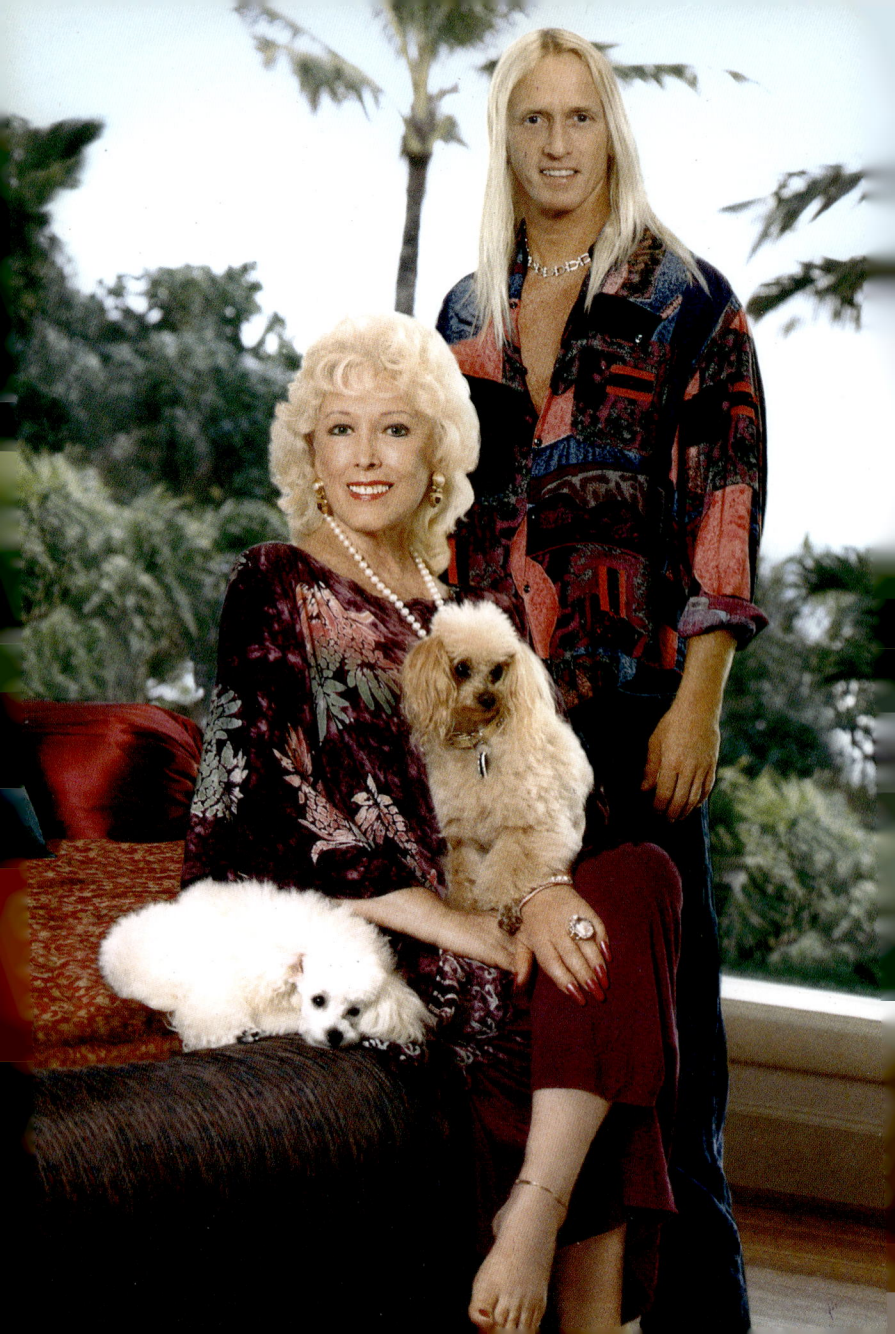

Dedication

I **AM VERY GRATEFUL** for God's instructions to write down His thoughts as they were given to me, resulting in this book of prayer for all to enjoy. Thank you, God.
I would like to express my gratitude to my loving son, Christian, for his guidance and belief in me, and for his beautiful creative talent, revealed in his paintings, that led to the inspiration of this book.

I am so grateful for my beautiful daughter, Reverend Dianne Winter, and my precious son, Ronald Lassen. I have been blessed to see the light of Christ shining in each of them.

Thank you, God, for my gentle grandson, Reverend Sean Peterson, his beautiful wife, Jessica, and their four adorable children, Shannel, Jena, Luke, and Jacob. Also for my beautiful grandsons, Tyson, Etsuo, and Garrett. I would also like to thank Susan Portabes for typing and editing these pages, and Julee Heffner for her visual design consulting.

— CAROL LASSEN

B **EGINNING WITH OUR FIRST BREATH,** there are many influences that shape our lives. The path we take is paved with love, guidance, and choices. Our journey leads us to understanding and truth. Thank you, God, for your infinite grace and gifts that have allowed me to express my vision of this bountiful earth through my paintings.

To my mother, Carol, for her profound love and belief in me. Her desire to bring me into this world was so intense that she was willing to put her faith in God and trust that His will would be done, regardless of physical obstacles that could have put her life at risk. Her willingness to encourage and inspire me at a young age continues to this day. She is a constant source of light on the path I have taken.

The inspirations contained within this book are a collection of her beliefs realized over the years, and I am so grateful that they now join with my vision of God's creations.

To my father, Walter, and wife, Dolores, my brother, Ronald, and my sister, Dianne. They also walk this path. Thank you for being a part of this journey and for all of your love and support.

— CHRISTIAN RIESE LASSEN

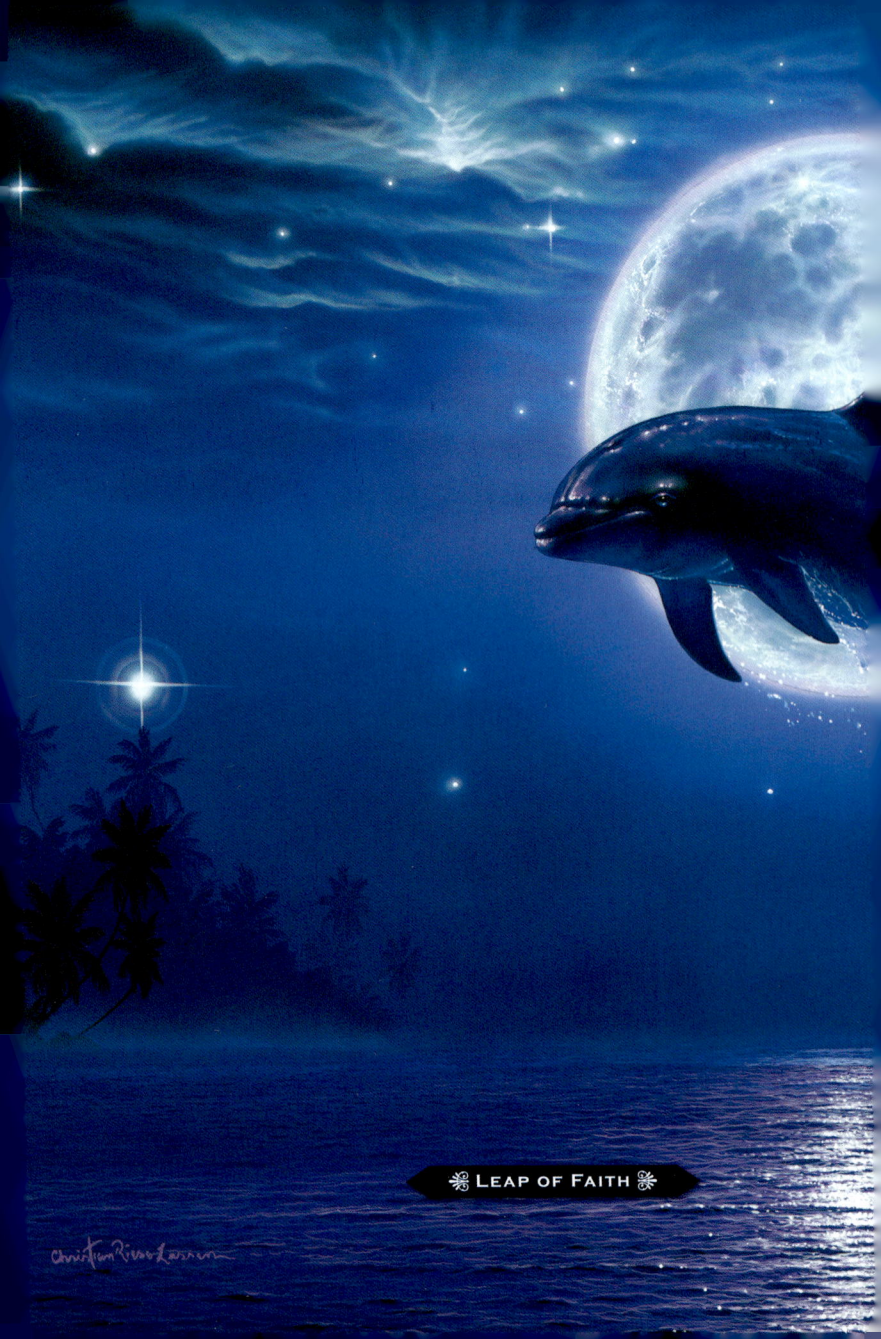
LEAP OF FAITH

Preface

I **AM WRITING** to you from Maui, Hawaii. My name is Carol Lassen. I am the mother of the world-renowned artist Christian Riese Lassen. The works of art in this book are some of his beautiful creations. I am sharing my story with you in hope that you may know that you too, can go to God and have faith and trust in Him. He does answer our prayers. I feel that Christian's birth was truly miraculous, and an answer to my prayers.

In 1955, I had a bit part in the movie, "East of Eden," starring James Dean. Elia Kazan was the director. During the filming of the movie, I was stricken with a severe case of polio. I found myself completely paralyzed and unable to breathe on my own. At that time I was living in Fort Bragg, California, and needed to travel 450 miles to the Children's Hospital in San

Francisco. That night, as I lay in an iron lung, I heard the doctors tell my husband that I might not live through the night, and to send for a priest or minister. My husband sent for a practitioner to pray for me, and I knew with prayers and faith in God that I would live. I was determined to walk out of the hospital in three months, which I did, with my nine-year-old daughter, Dianne, on one side and my father on the other side, supporting me.

The only way the doctors would release me from the hospital was with the understanding that I would be transferred to the hospital near my parents' home, if it was equipped with an iron lung. I was told that after six hours outside an iron lung, I would not be able to breathe on my own. I talked my parents into taking me to their home so I could visit with my children. In my heart, I knew I could not live in an iron lung in a hospital any longer. I told my mother this, and she became frightened and called the doctors. They came to her home and examined me and tried to persuade me to go back to the hospital. I told them I would not go back, but instead, would rely on God and the power of prayer!

THAT NIGHT, I pleaded with my parents to leave me in God's hands, and to check on me in the morning. I completely surrendered myself to God's will, and prayed that if it was His

will, I would live. I knew in my heart I was safe with God. What a glorious night that was, my first peaceful and heavenly night's sleep!

At that time, along with my daughter Dianne, I had a ten-month-old son, Ron. I had longed for another baby and hoped it would be a boy so that Ron would have a brother to grow up with. My doctors told me I was unable to carry a baby full term because of the weakness in my body. A pregnancy would also affect my breathing. I prayed to God that I would be blessed with a baby boy. I planned to name him Christian, after His son. I would raise him in God's word, and we would serve Him.

Sometime later when my doctor became aware of my pregnancy, he advised me to have an abortion right away. In my heart, I knew this pregnancy was a gift from God. My baby was a boy, 8-1/2 pounds, a blond, blue-eyed angel. Along with his first breath, he looked right at me with a big smile on his face, as if to say "Here I am!" It was such a thrill to name him Christian, as I had planned.

He was born an old soul, with a knowledge of God that has intrigued me. When he was around the age of four, I would read to him from my spiritual books, or talk to him about God. He would give me deeper insights that have continued to this day.

From an early age, I realized he was especially gifted as an artist. His drawings could have been illustrations in an encyclopedia. Almost every day of his life since, he has spent countless hours drawing and painting on anything and everything he can get his hands on, including walls, cedar chests and surfboards.

OVER THE YEARS, Christian has become one of the world's most renowned environmental artists. He has given back to the world by developing two foundations that he has given me the privilege of directing. The Lassen International Fund is dedicated to helping the less fortunate, and Sea Vision Foundation is for the ocean's ecology and all its inhabitants. These foundations are funded by the proceeds of his artwork. Christian is actively involved with the preservation and protection of marine life and the oceans.

In 1992, Christian was selected to create a commemorative stamp calling for the preservation of the world's oceans. The "Friends of the United Nations" announced the appointment of Christian Riese Lassen as their "Goodwill Ambassador" for the United Nations' 1998 "Year of the Ocean."

Christian has released two CDs. One is "Turn the Tide,"

 and he is the lead vocal. The first song, "Cry a Tear," is the earth's plea. The fourth song, "Turn the Tide," is about ecology. These two songs, along with "Where's Your Kiss," are my favorites. I didn't know Christian had such a beautiful voice, as I had never heard him sing a note. Then one day, he informed me he was working on a CD and was the lead singer. What a surprise! The other CD is an instrumental called "Ocean Healing."

Christian has also starred in a full-length movie, "I am the Earth." This movie deals with dolphins and the ecology.

So you can see how proud I am of my son for all his accomplishments. Christian and I give all the glory to God for making this happen.

I hope that in sharing this story, others will be encouraged to know that no matter how insurmountable things may seem, they too can put their trust in God! Thank God I listened to that small, still voice within saying, "This is the way, this is the way." I feel Christian's life was meant to be, for he truly is a servant of God. He has been a blessing to me, his family and countless others.

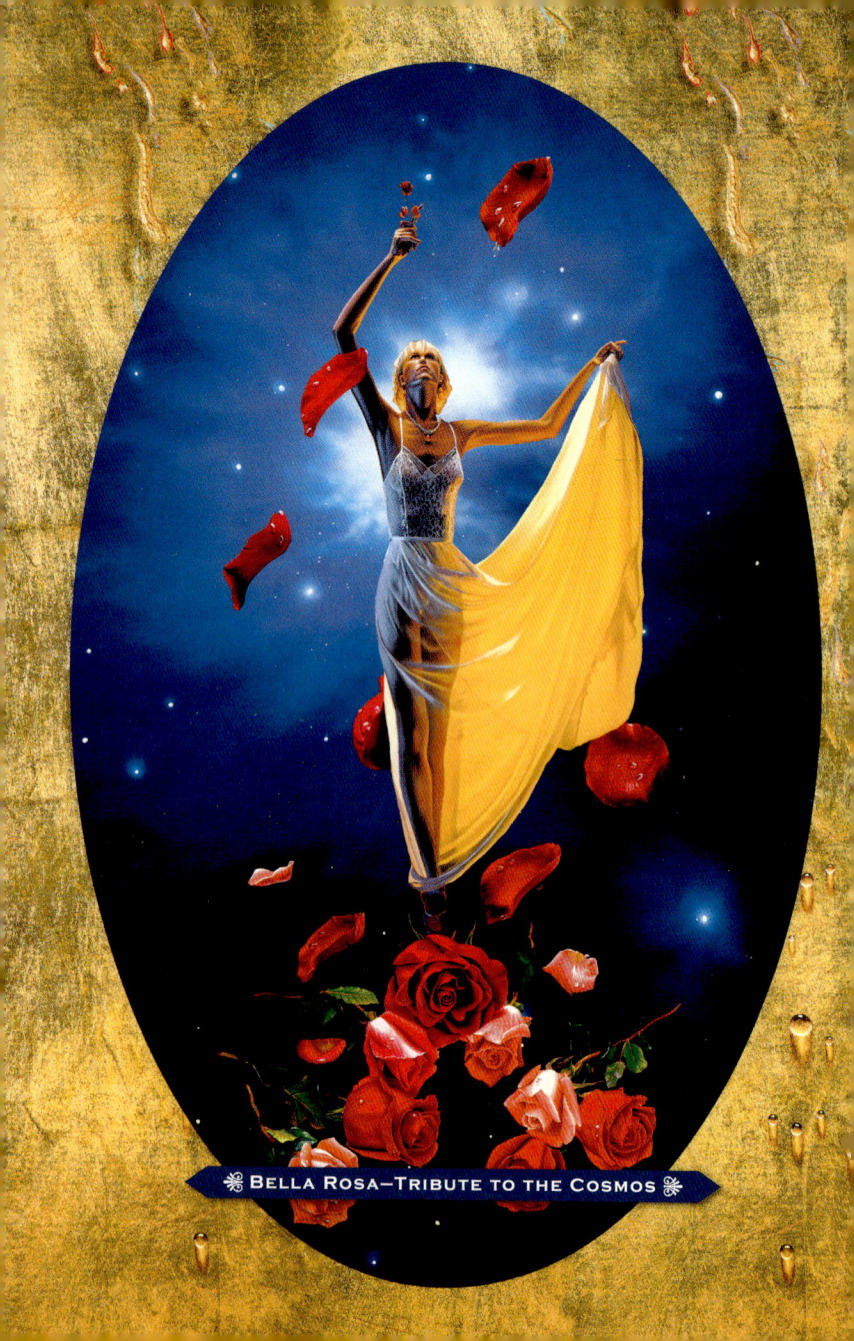

Bella Rosa—Tribute to the Cosmos

The Door

WHEN LIFE ON EARTH becomes too heavy, and our load seems to be more than we can carry, we are told there is a way out, while still living in the here and now. We can drop the mortal mind and choose not to listen to the tapes unwinding in our heads, always having us judge the past, and reliving those experiences in the now. At these times we find ourselves searching for the door to escape. If we believe we can patch up our problems by material means, we've lost our way. We will never find peace in this world. There always will be wars, sickness, death, and catastrophe in this temporal world. Give up thoughts of imperfection. Stop the judgment of good and bad. Surrender yourself to God. Without Him in our lives there is no everlasting peace. Life without God is like a yo-yo.

Let us hear Him calling, telling us, This is the way! Let Me live for you, as you. Let His will be done, and watch as we see Him in action, bringing everything to our doorstep as it is needed to serve Him.

Let us step out of the role we are playing and live a life free of self. God lives, not I. Let us give power only to God, knowing

He is all life, expressing Himself in perfect order. The peace we feel when we let go of our burdens and give the whole load to God to carry for us is the truth that sets us free. The government is upon His shoulders and we should trust Him to make all our crooked ways straight.

We will feel His love for us. The assurance of His promise is to give us peace and heavenly rest. The feeling is light and joyous. Our burdens lift, our pain disappears, when we abide in His Kingdom. All things perfect are added unto us. Our cup runs over. There is nothing to fear, the Invisible Splendor lives as all.

We can find the way to this perfect existence by going within, choosing not to listen to the mortal mind. Stop believing that the body is our life and find the one Life of God that lives eternally in Consciousness. The One Body of God is the invisible Eternal Power of all that is. He is All in All. There is no other Life than God.

He lives our life as us, when we sincerely long for His love and care. He will never leave us. We have left Him by giving power to a life we called our own, struggling to make all the pieces fit.

We are told to let God live in our minds, body, and soul, for He is the Father, Son, and Holy Spirit. He is the Divine Mind. His

body is the only true substance existing. There is none else. His Kingdom fills all space. He is everywhere present. He is the only power. He is the Soul and Holy Spirit of all there is. He is our very Life.

God's Kingdom is here now. There is no space God is not already filling. We find this true creation by being still, quieting the mortal mind, and feeling God's presence in our consciousness. He lives there. We are told He can be found by seeking Him within our consciousness. We can become one with this Life by wanting God to live as us. For this is our true being. This is the truth that makes us free. This place we call Heaven is here and now. We only need to walk the path to His temple and God will send His angels to take our hand and lead us into His Kingdom. It's only a thought away, a thin veil of hypnotism to awaken from.

Awake! Awake! God lives, not I. Thank God for this truth, that we may dwell in His Kingdom forever. He is everlasting, without beginning or end. Life eternal is given to us by His Grace.

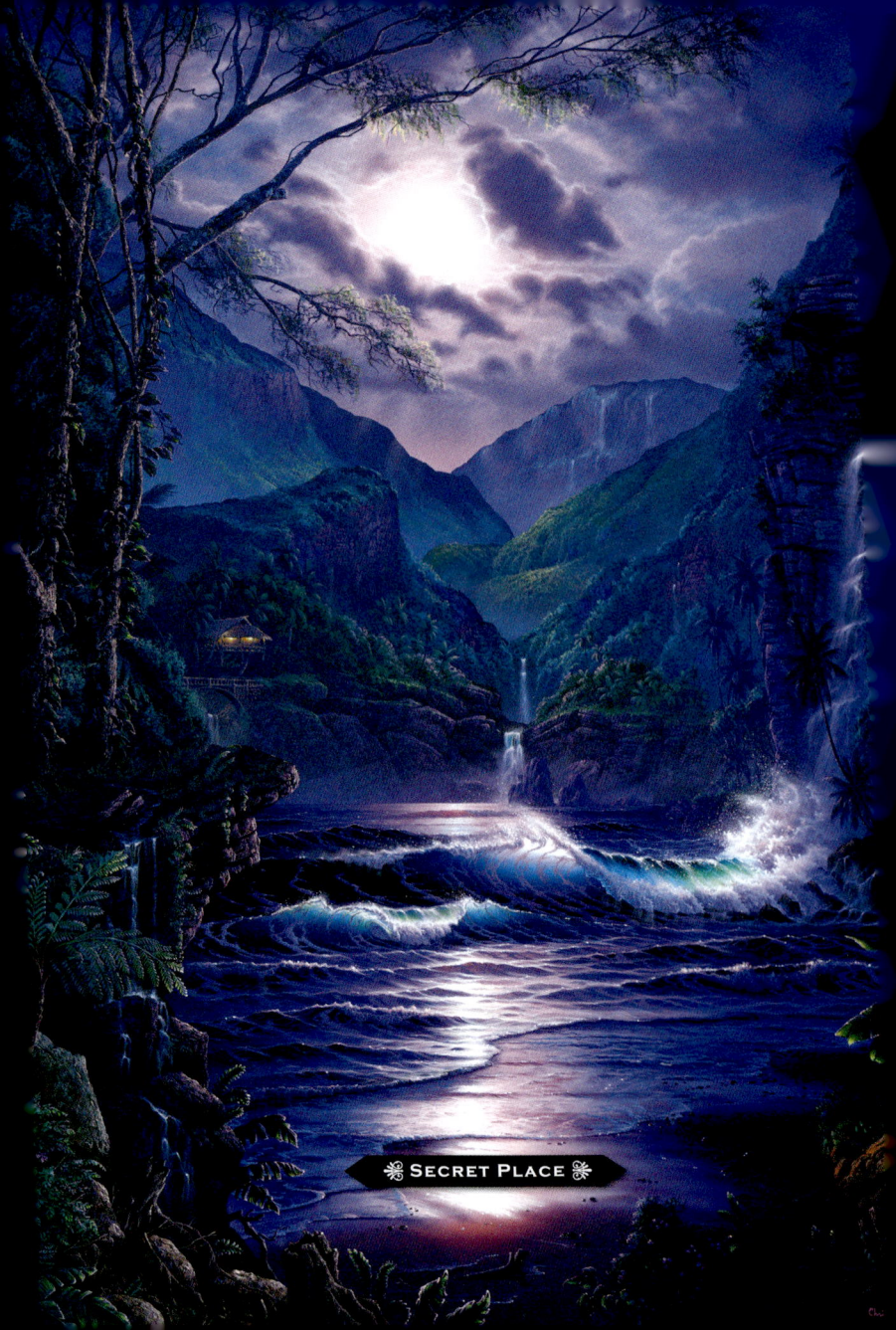

The Secret Place

I **KNEEL BEFORE** your presence with gratitude for all your care and compassion. The Love I feel melting my soul is pure bliss. To dwell in your Kingdom is a freedom that lifts me on angel wings above the earth. All the heavy chains of fear are left behind as I fly with the angels in your Kingdom, to that secret place within my consciousness.

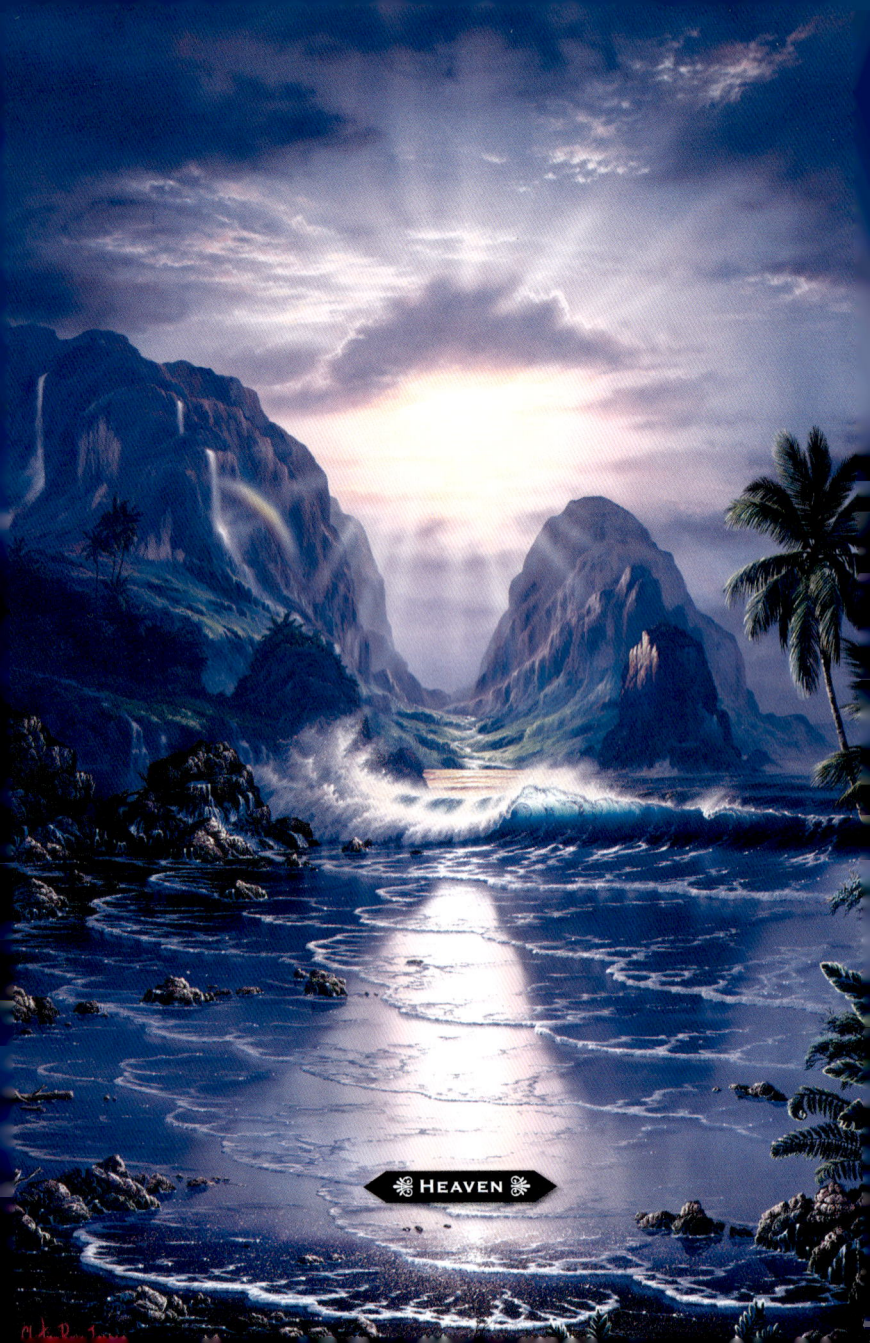

The Gift

WITHIN THE TEMPLE of our conscious self

 we can feel God's love for us.

He sends the Christ to lovingly, tenderly

 guide us into the light.

I humbly let Him wrap me in

 His cloak of sweet, pure love.

He guides me into the most brilliant white light,

 not seen by the world.

There I kneel in God's presence. God lives, not I.

The freedom felt in His Kingdom is the peace of pure bliss as

 His light showers me with His powerful Love.

My prayer is to let His Love live in my heart to bless others.

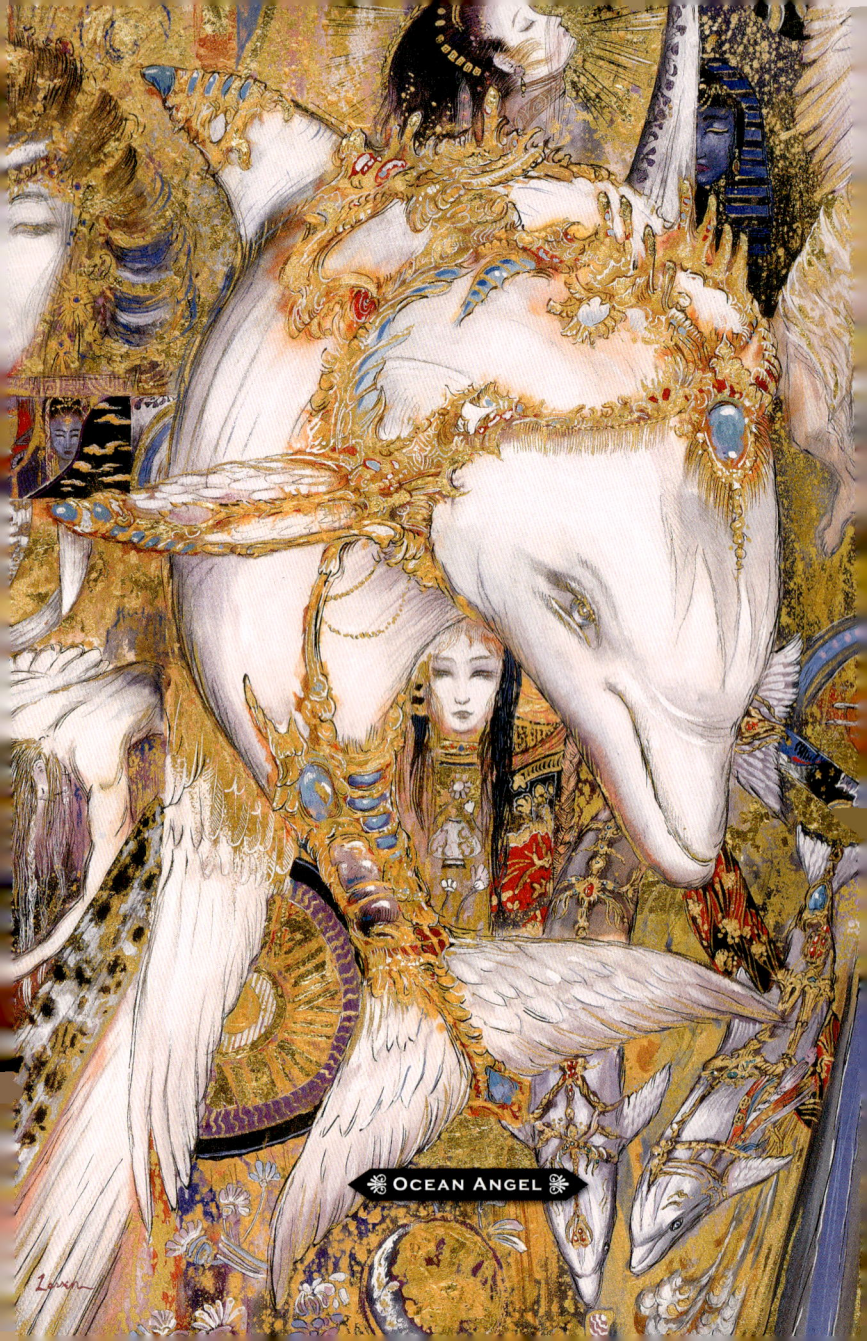

Ocean Angel

The Mystical Marriage

WHEN WE RETIRE WITHIN OUR CONSCIOUSNESS and find that secret place of the most high, the holy of holies, we dwell in the Kingdom of God. There we become one with the Divine Presence. There is only One Life to be found living within His Temple. Our conscious self weds with our divine Self in heavenly bliss. Feeling God's presence, we dance in joy for His invisible splendor. A song of love bursts from our soul to sing of His glory. The world disappears before the throne of His spiritual power as He rushes to our doorstep with gifts. By His Grace our dreams become reality.

Our cup runs over. Our every desire fades before His Allness. There is nothing to pray for—God is already All. In this wedded bliss, we celebrate our mystical marriage, being One with God in the timeless dance.

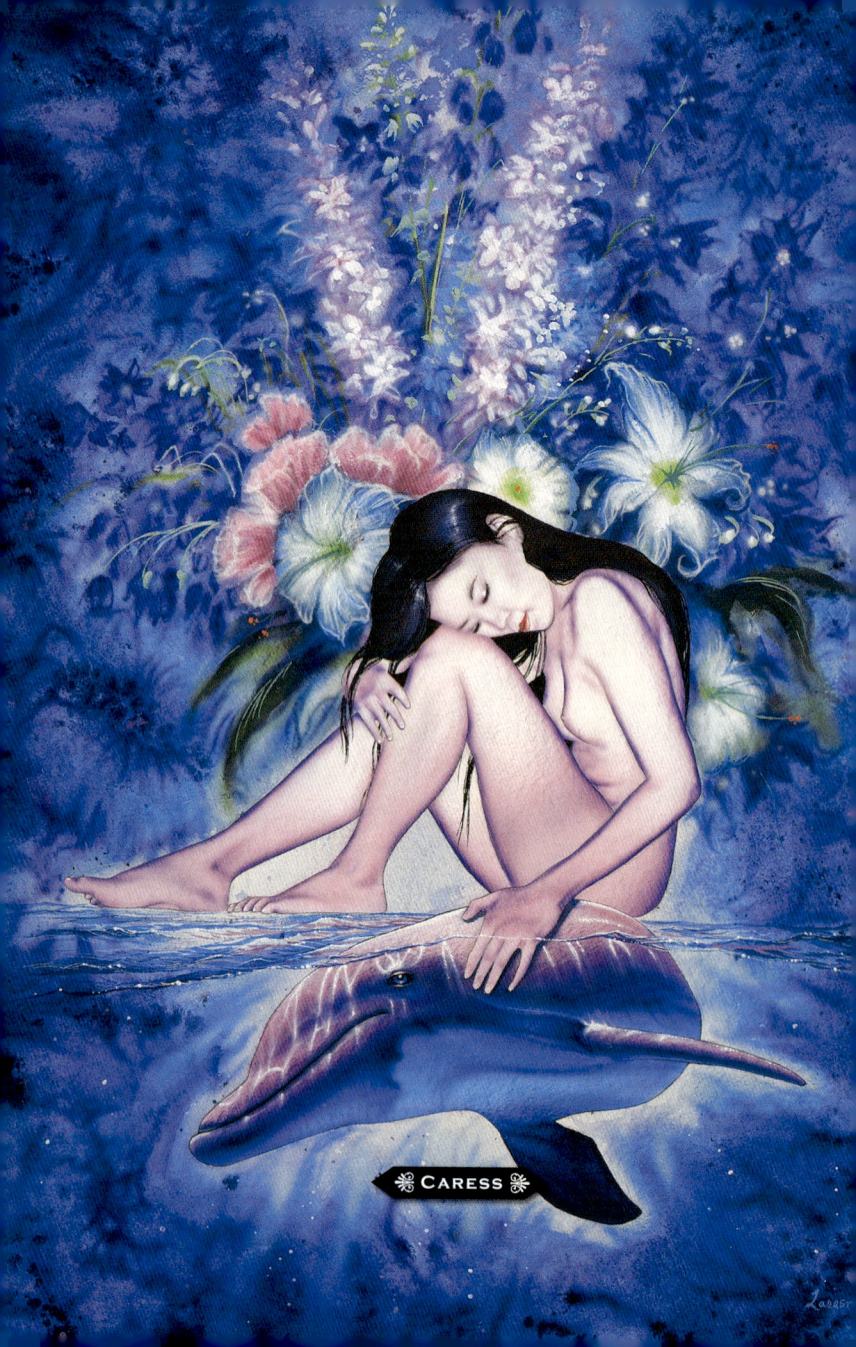

Because of You

BECAUSE OF YOU, I feel loved. Your touch melts my fears. Cradled in your arms, I am lifted into paradise. Your beauty and strength fill my soul, as we become One in a bursting, brilliant shower of light.

Because of You, I feel your tenderness, so sweet and caring. I kneel in your presence, surrendering in anticipation of your glory, as You lift me into Heaven.

Because of You, I never feel alone. I know You are always there for me. The pit of fire will not kindle me as I walk this path with You at my side, leading me. How deep your love is, so sweet, so beautiful, because of You.

I love You, Divine One, with a heart overflowing with tears of joy, celebrating that I am part of your pure, sweet splendor.

Because of You, I know what love is.

Because of You, my life is eternal.

Because of You, I will never be alone, for You are my life.

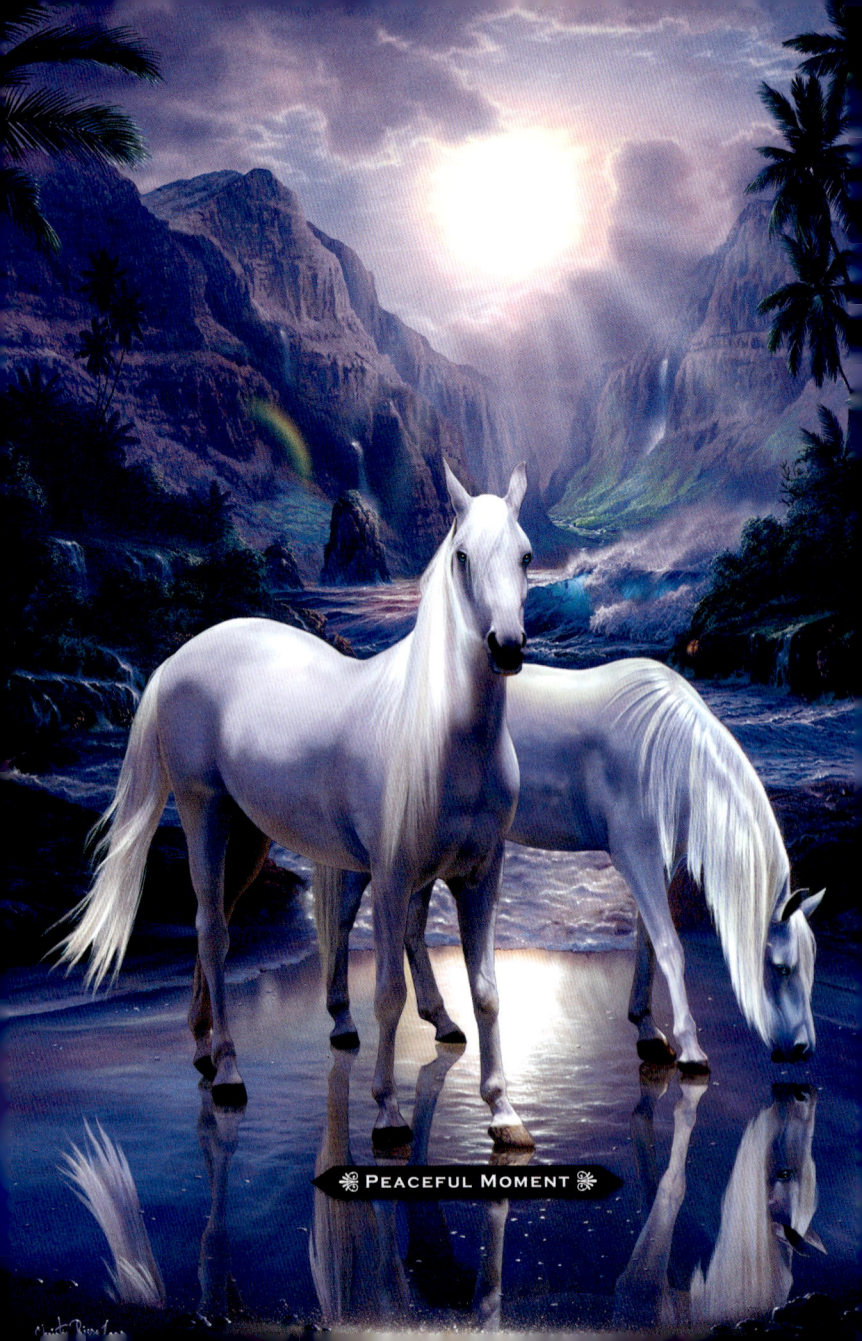

My Humble Prayer

MY HUMBLE PRAYER, dear God, is to serve You, to share with those I find on this path to your Kingdom, and to let your will be done.

I pray to surrender ego, a self lived apart from You. It will be my joy to watch God in action when I let go. Then everything will be in perfect order in this eternal now. I pray, Lord, to awaken from the dream world of control and fear.

I pray to be aware of the reality of life, the true Spiritual Life of God living His Life as All. I pray to stop judging this dream and awaken to God's spiritual reality, and give up the belief of a personal life in matter, for God is the only Life.

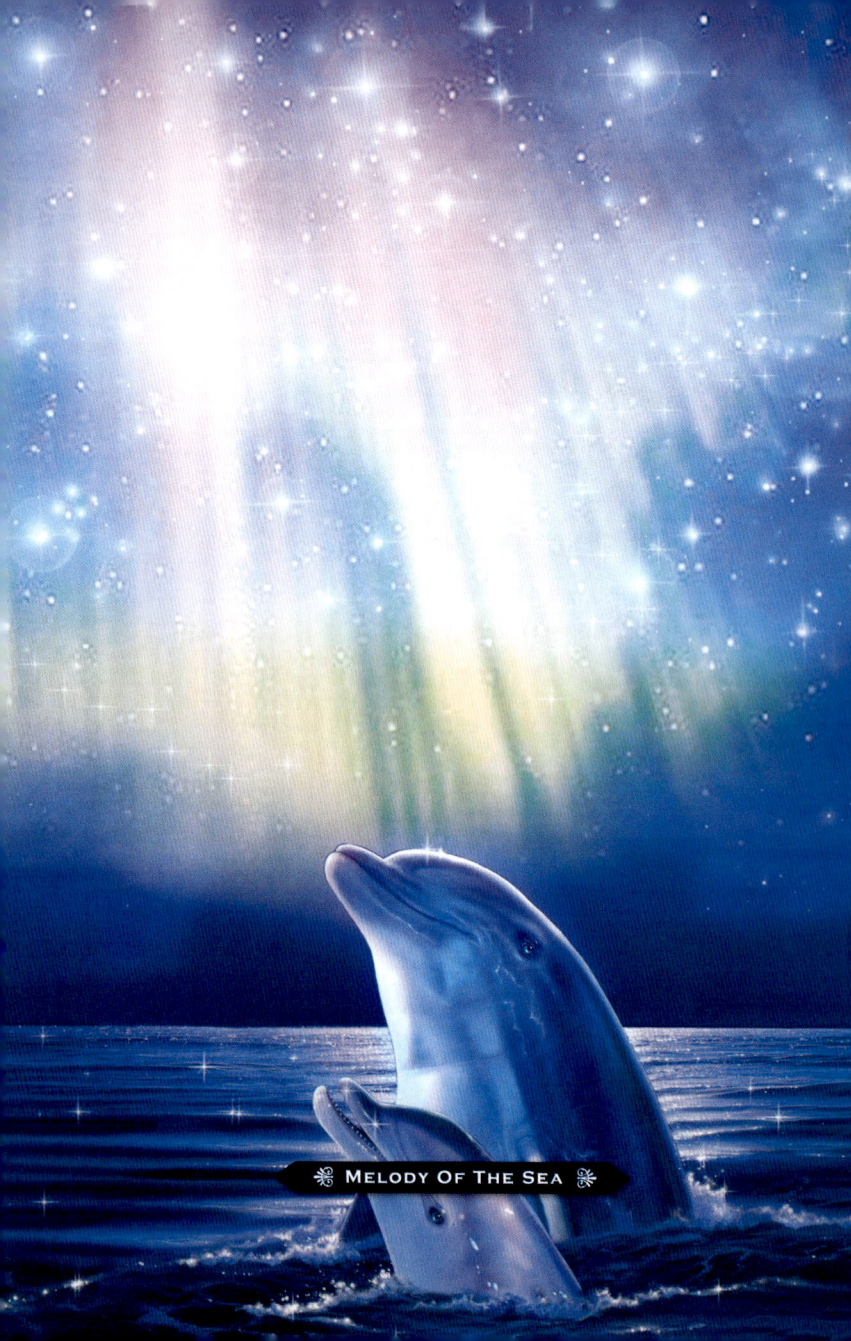

His Angels Rejoice

GOD'S PRESENCE fills my very soul, and I feel like singing as His angels rejoice, because I have found His Kingdom. They celebrate with glee and mirth just for me. My cup runs over with living waters of love. Thank You, God, that You have prepared this Temple within, for everyone to share. God waits for all His children to find their Heavenly bliss in His Kingdom. I love You, God.

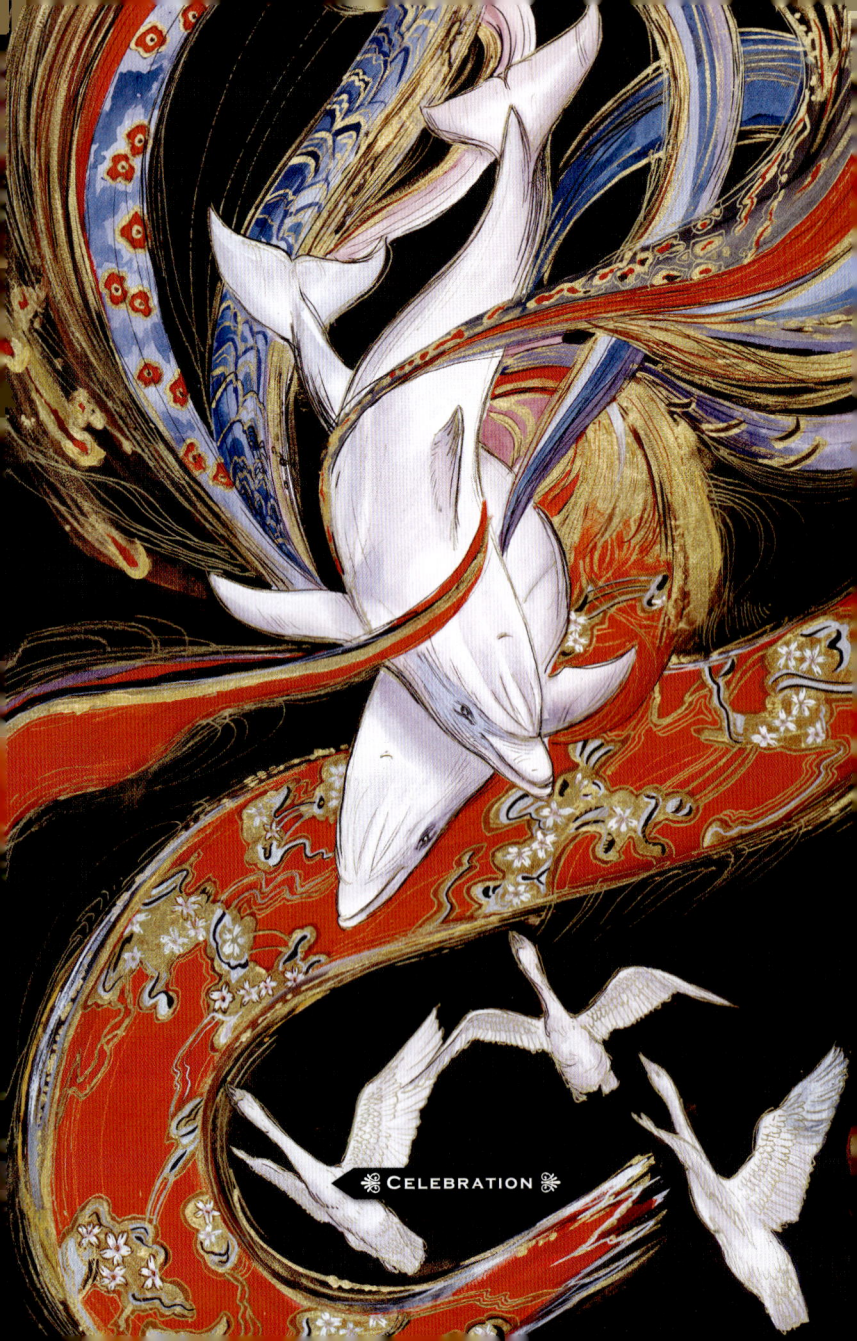

❖ Celebration ❖

Wedded Bliss

I SURRENDER TO BECOME ONE with the perfect bliss of God. The truth of this reality frees me. I dance with joy in His temple of Love. I am safe, I am loved. He will never leave or forsake me. I am made in His image and likeness. God is infinite, the only life, filling all space. God is, so I am.

There is nothing else. God is all life. God lives, not I. Let His will be done, not ours. Heaven cannot be found any other way. Seek the Kingdom where God lives within our consciousness.

His Presence is Mighty

SUPREME BLISS EMBRACES my being when I fill my consciousness with God's Allness. To become aware of the Infinite Power, existing everywhere in this Eternal Now, bursts forth feelings of joy, bathing my very soul with overwhelming delight.

The power of His love melts away all thought of a life apart from Him. This is our Heaven, when we feel His touch. His Kingdom is found living within. I feel His gift of grace, His power is omnipotent. To become One with His mighty presence is the mystical marriage! How great is His glory. God is All, in All, as All.

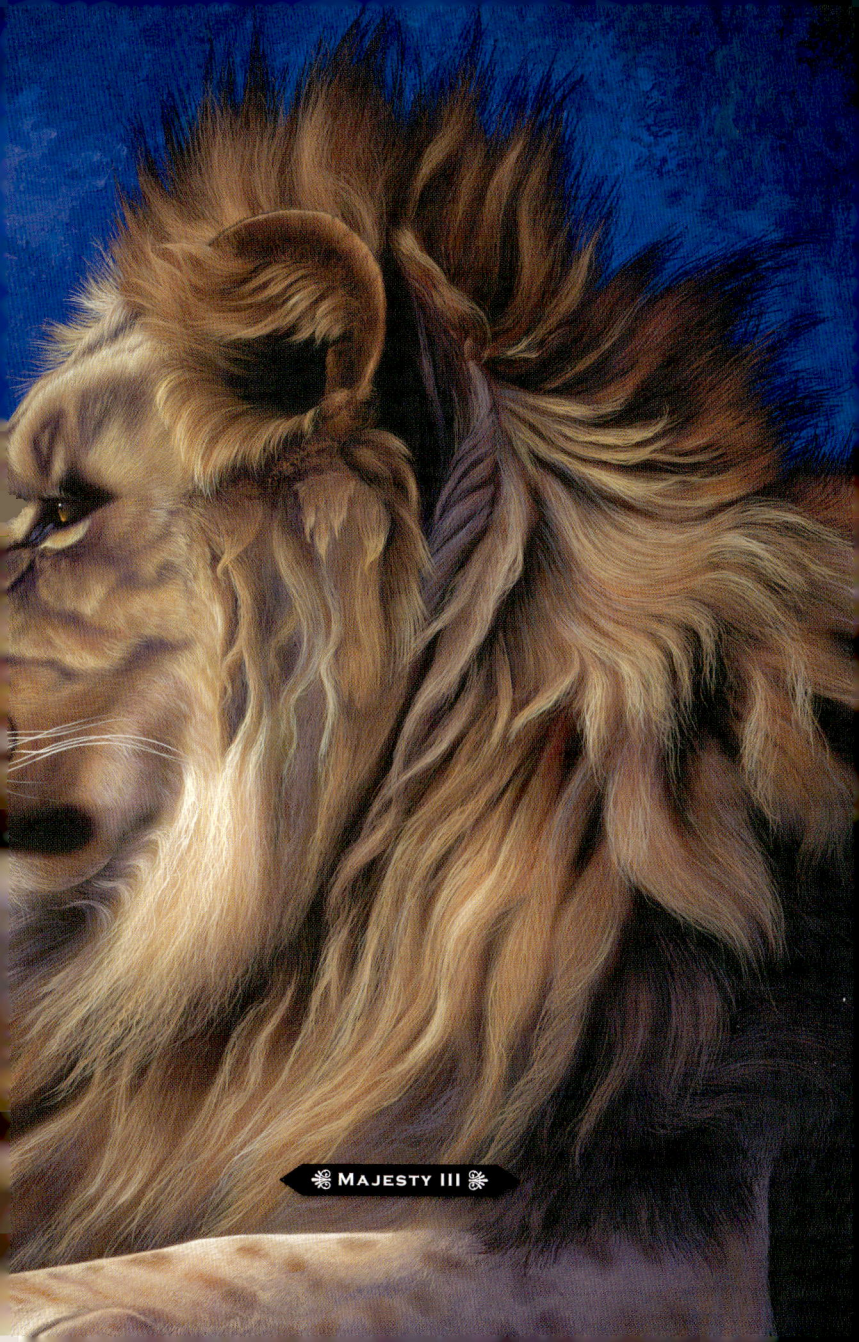

MAJESTY III

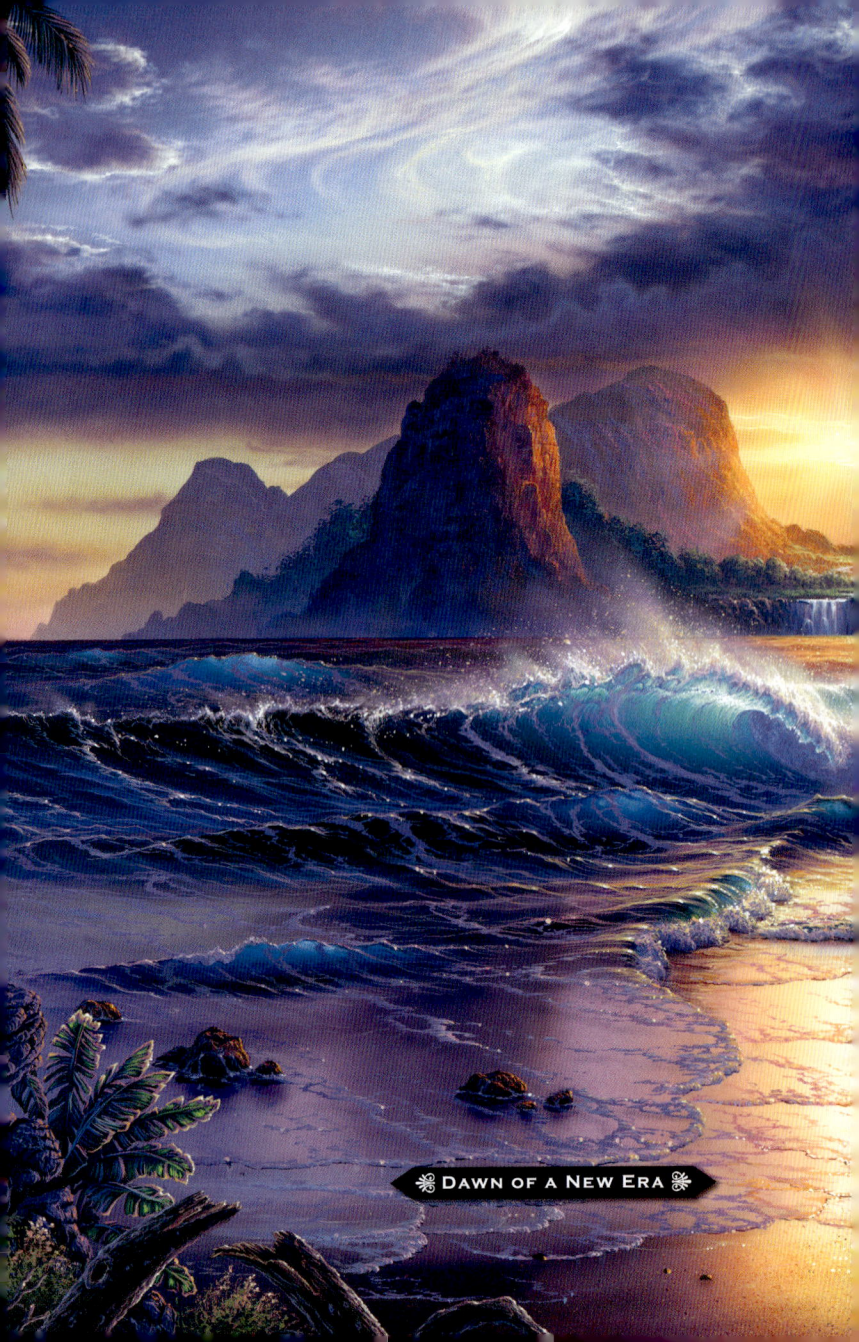

DAWN OF A NEW ERA

Our Creator

How wondrous are your ways. How beautiful is your love. How powerful is your strength. How still is your peace. How blissful is your joy. I am humble before your Presence. I dance with joy because of the freedom I feel, by being at One with You. In your Presence, I lose sight of self. All fear disappears before the throne of the Almighty. All pain melts with the warmth of your love. You are Life Eternal. By your grace You give life without end.

A spiritual life to be lived with You in Heaven, throughout all eternity—what more could I ever pray for? My only prayer is to know my Oneness with You, to listen to your invisible splendor, telling me how much I am loved, and to hear your voice whispering, "This is the way, this is the way," until it thunders in my ears.

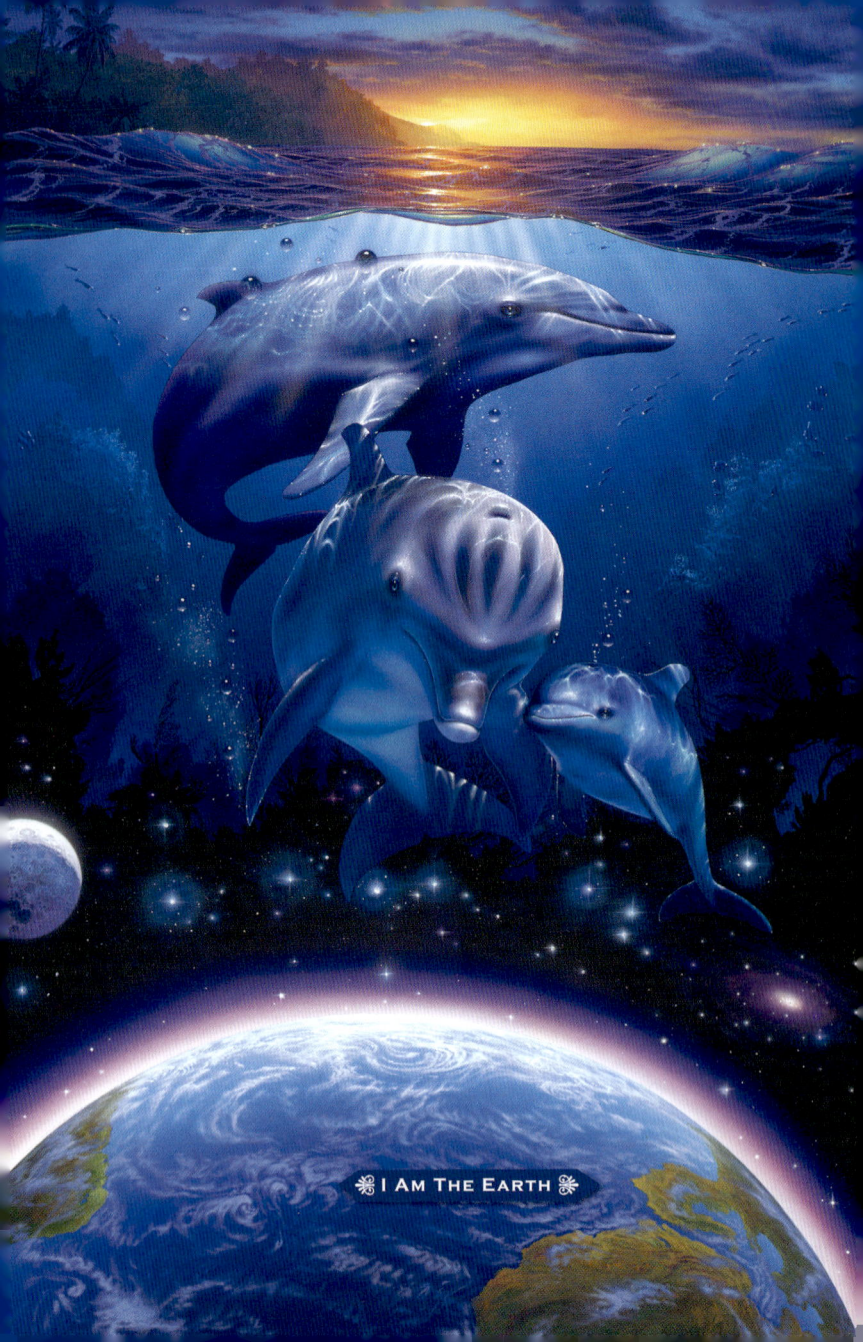

I Hunger

I **HUNGER FOR PEACE** and rest with You, dear God. You lift me with arms of love into your Kingdom, where no mortal has ever entered. For "flesh and blood cannot enter the Kingdom of God," and no eyes can behold the face of God. My soul is complete and whole with your sweet, pure love that covers me in your Kingdom, within my consciousness. I find only joy there, and the feeling of being completely safe is heavenly. All fear is gone, as your power protects and sustains me. I feel free of all ego and my mortal body as You take me into the Light.

❈ Moonlit Cove ❈

The Eternal Now

The truth is, God is Eternal. The truth is, God lives as All. His Life is our Life. All of God's creation is perfect.

When we choose to know this truth and let God live as us, letting His will be done, not ours, we are free to be at peace with God in the Eternal Now.

B ECKONING L IGHT

Beckoning Light

I feel your Love in the glow of every sunset.
I know your presence in this Eternal
Now, as the "All in All."

I see your beauty in all
creation that surrounds us.

I wonder at your mighty power
in the movements of the oceans.

I surrender my life to God,
as His divine energy
brings peace to my soul.

PARENTHESIS ETERNITY

Knowing the Truth

I KNEEL IN HUMBLE PRAYER before the Divine Creator, asking to know the truth of my Oneness with all Life, wanting only that which will open my consciousness so I can dwell in God's presence, being at One with Him.

I pray to know my divine purpose, to do His will, and to serve Him only. Then I will find heaven in this Eternal Now.

We can serve God by helping one another and loving all of God's creations.

To care for even the least of these is to honor our Maker, for He is "All in All."

When we serve God, we are blessed. The cup we offer to be filled by His Grace overflows with added gifts! Oh, how wondrous are your ways!

MARYEVE

Divine Presence

OH, DIVINE PRESENCE, how heavenly is your touch of love! Oh, how wonderful it is to know You, to know that You are omnipotent, all power, the only power there is!

It is reassuring to know I am so loved, that the infinite Creator made me in His image and likeness, at One with Him. God is my life, the only life there is, God living as "All in All."

There is nothing to fear if we let His will be done! Surrender our life and let God live as us. The Christ lives within our consciousness. To know this truth frees us from sin, disease, and death. "God lives not I."

To live in the Kingdom of God is pure bliss. By His grace we are One with all that is!

❈ Illuminations ❈

The Path to the Kingdom

This place we call Heaven is here and now. We need to find His Kingdom within our consciousness and ask the Christ to enter. God will send His angels, to take our hand and lead us into His Temple within.

It is only a thought away a thin veil of illusion to awaken from. Awake! Awake! God is "All in All." God lives, not I.

Thank You God, for this truth, that we may dwell in your Kingdom forever. God is everlasting, without beginning or end. Life Eternal is given by His Grace.

※ TRANQUIL MOMENT ※

Glory be to God

GLORY BE TO GOD, the Most High. By His grace He gives all that is needed. Our cup runs over from His abundance. He will never forsake us. He will be with us from everlasting to everlasting. He tells us to "Come unto me, let me lift you into Paradise. I will lead you. If you fall, I will raise you up. You are my child, made in my image and likeness, with whom I am well pleased." Your home is where I am, throughout all eternity. Wherever you are, I am there. I am your real Self, for we are One. Let go and be reborn in the Spirit of God." God lives, not I.

※ DOMINION ※

My Prayer

I PRAY TO FEEL your presence. On angel's wings, I am lifted into the Kingdom of Love.

I pray to know the truth of Life as Spirit, made in your image and likeness, to live throughout all eternity at One with You, God. Oh, how wondrous are your ways. My heart overflows with joyous gratitude as I peek into your temple of Love.

Thank you for your Grace, Creator of all that is divine.

❊ INDIGO NIGHT ❊

My Reward

I LOVE SERVING You God, as I know it pleases You. My reward is the pleasure and joy I receive. Your Grace fills my soul, as I feel your peace. I pray to keep my consciousness aware of your presence. When your will is done, the world stops its clamor. I kneel in your temple, to listen to that still, small voice thundering in my ears, "This is the way! This is the way!" Oh, God, let me love all of your creations, and help me nurture this beautiful world, in appreciation for all You are.

Maui Magic

God's Promise

I **HEAR GOD'S VOICE** within telling me, "You are my Beloved Child with whom I am well pleased. You are made in my image and likeness.

"My Life and Light is within you, for we are one. You will dwell with me in my Kingdom, that secret place in my Temple of Love, for all eternity. There you are safe and cared for.

"All that I have is yours. In that secret place within your consciousness, I send the most loving angels to care for your every need. There, you will find your Heavenly rest. My Peace and Love fill your soul.

"You will sing with joy to the rhythm of Heaven's music in this timeless dance, forever and ever."

SERENE SANCTUARY

Living Waters of Love

I FEEL LOVED and cared for as I am lifted into Heaven by Your Grace, that secret, sacred place found within our being. Oh, how wonderful is your mighty presence, dear God. I kneel before You in humble gratitude as You shower me with living waters of love. You bathe my soul with your compassion and caring. I am free to dance with the angels to the beat of my heart, singing praises of your love. When I find myself living within Your temple, I am home, safe, and free.

Bora Bora

Trust

I **KNOW I CAN TRUST YOU**, God, with my very life. I do not need to be afraid, for You are always there, within my soul. The waters cannot drown me, the fires cannot devour me, the earth cannot shake me, for God is my life. Death has no hold on Eternal Life. Though I may go through the shadow of death, it is only a shadow, for Life is the everlasting light. Your light leads me to be One with You.

❋ Starry Eyes ❋

The Still Small Voice

I LONG TO HEAR THAT "still small voice" within my consciousness telling me I am loved, that I have Eternal Life. I never need to fear, not even death. I long to feel God's presence, as He bathes my soul with the sweet warmth of His perfect love. I long to dwell in His Kingdom, for there I find my heavenly rest, my peace, my true Self, one with God. My cup overflows with joy as I let go. "God is all there is! There is none else."

My feelings of gratitude fly with the angels for the splendor of God's Allness.

❋ Perfect Balance ❋

The Resurrection

WHEN WE ARE AWAKENED from the tomb of life in matter, we will be resurrected to know God as our Life.

The "I am," as being "All in All," is the One Eternal Spirit, ever present. We are perfect in His image and likeness.

There is only God filling all space. There is no other place to live. There is no other Life but the Life of God. The "I am" is "All in All" now. Knowing this truth is the resurrection of life, our life, lived as the One Life.

Thank You, God, for my perfect, spiritual form, made in your image and likeness.

DOLPHIN EMBRACE

Love One Another

MY PRAYER IS TO FEEL God's presence within my being.

My deep desire is to know the "I am" within as God's Life as me.

For we are made in His image and His likeness.

God is all, there is none else.

My humble wish is to serve Him only.

To love one another.

To do unto others as we would unto Him.

To comfort those who suffer.

To feed the hungry, heal the sick, to give to the less fortunate.

And the greatest of these is Love.

My heart cries out to the innocent victims of man's inhumane behavior towards the oppressed and all of God's creations.

Mt. Fuji

A Joy to Behold

I KNEEL BEFORE YOUR PRESENCE in gratitude for all your care and compassion. The love I feel melting my soul is pure bliss.

To dwell in your kingdom is a freedom that lifts us on angel wings above the earth. All the heavy chains of fear are left behind when we fly with the angels in your Kingdom. Thank You, God, for showing us the way to that secret place within our consciousness where we find You always there, to love us and shower us with your gifts that bring us peace.

Your love and compassion and the safety You bring are joys to behold.

Being in the presence of God, and feeling our Oneness, is like nestling under the wings of Angels. Glory to God.

❋ Free Spirit ❋

Wings of Love

GOD'S THOUGHTS ARE CARRIED by His angels on wings of Love to tell us of His care. They whisper ever so softly of His divine plans for His children, His tender devotion, His fortress of safety, and the love He bestows throughout all eternity.

When we listen for "His voice" and let "His will be done," we live by His Grace and all the added things are given freely. All struggle ceases. We find joy in giving to others as we share God's gifts.

❋ Amber Dawn ❋

The Shelter of His Love

Thank you, God, for the shelter I find in your Kingdom, for it is always there, waiting to be given by your Grace, when we seek You. I want to serve You, Divine Light.

I am so grateful for all the gifts that You share, for Life eternal, peace, rest, love, joy, wholeness, strength, power, and all that You are, for You are the giver of all.

❈ Heritage ❈

The One

WHEN WE GO WITHIN our consciousness and surrender all thought of self as having a life of our own, with all its troubles, and pray to feel God's touch, we find a peace coming over us, covering our whole being with a love so sweet, it's heavenly.

There in His temple, that secret place within, we feel His presence and know we are safe from all harm. God lives there and waits for us to know our Oneness with Him. Oh, what peace and joy it is to let go and let God live as us.

❋ Cosmic Children ❋

Surrender

A COMPLETE SURRENDER IS TOTAL BLISS as I live at One with God in the Eternal Now. All thought of life as lived separate and apart from the One Life vanishes as I realize God lives, not I. God is my life. For this is the Truth that sets us free from the beliefs of sin, disease, and death.

※ TOGETHERNESS ※

Choose This Day

We have a choice, to choose to do God's will and to serve Him. This will bring us perfect peace and free us from all worldly conditions and experiences that are not of God. We can choose to drop the heavy load of life, in and of matter, and let God live as us. Let His will on earth be done. Surrender the life we thought separate and become One with the Divine Presence, God.

Kapalua Serenity

His Temple Within

I FEEL GOD'S PRESENCE living within His temple of my inner being.

I feel love and protection there. His peace bathes my soul with living waters of Love. God lives in the Eternal Now.

In His Kingdom there is freedom from the fears of mortal life, a life separate and apart from the One Life. God lives as All. We are One.

Cubist Face

Angel Thoughts

DEAR GOD, I FEEL YOUR PRESENCE surrounding me in the stillness of this Eternal Now. Your peace and power engulf my being with overwhelming delights.

Your Allness fills all space as I feel my Oneness with all that is.

Thoughts of Love lift me into paradise on wings of gratitude and prayer when I find Him living within my consciousness.

God is All as All. God is living in all creation.

God lives, not I. God is, therefore I am.

Thank You God

THANK YOU, GOD, FOR SHOWING US that secret place within our consciousness. You are always there, loving us and sharing your gifts that bring us peace, compassion, and safety, a joy to behold.

Being in the presence of God and feeling our Oneness with Him is like nestling under the wings of the Almighty. Glory to God!

❈ Christine ❈

❊ MYSTICAL JOURNEY ❊

Life as Spirit

TO FEEL THE FREEDOM OF LIFE as spirit is paradise felt and a springboard into heaven. Being cradled in the arms of Love is a bliss not felt when life is lived in the material world.

To be "absent from the body and present with God" is ever available in this Eternal Now.

Whenever we choose to seek God in that secret place within, we find our true home and heavenly rest.

❋ Secret Path ❋

Reality

WHEN JOY AND GRATITUDE is felt for God's gifts, it is heavenly. To be able to know and feel God's love for His children brings such a sense of peace. To know we have a Heavenly Father who created us in His own image and likeness frees us from our heavy burdens of fear. Knowing the true reality of Life as God, at One with everything, is the Truth. "He is All in All." He is closer than our own breath.

God, Life, Love or whatever we choose to call this invisible splendor, Is! There is no reality to anything that God's Kingdom does not include. Everything temporal is not the spiritual Eternal Life that God is. God is from everlasting to everlasting and we, His children, made in His image and likeness, have been given this wondrous gift. By His Grace we have Life Eternal.

❋ SILENT JOURNEY ❋

Flying with Angels

I FIND PEACE AND HEAVENLY REST when your angels carry me to your temple of Love. Nestled beneath their wings, I am lifted into paradise, to be One with You. In that secret place of the Most High we lose sight of self, for God is "All in All." There is none else! God lives, not I.

Oh, how glorious the bliss feels as this truth is known. I am home free, flying with the angels.

❊ Lahaina Harbor Lights ❊

I Am Love

Thank You, God, for being the only Giver of all. You are my life. My supply is given by your Grace when I choose to let go and let God live as me. You will prosper me, and show me my divine purpose. Your will is done when I choose to surrender self and be reborn in Your Spirit, made in your image and likeness. God is my Life.

I am at one with Love, the Love that is in all. God is Love.

Maui Moon III

God in Action

I CAN SEE GOD IN ACTION when I let go, witnessing the play of Love and watching God reveal Himself as "All in All."

LORDS OF THE MILLENNIUM

God's Will

LET US GIVE OUR WILL to God and let His will be "done on earth as it is in Heaven." Let us seek the Kingdom of God that is waiting for us, the place God intended, just for you and I, that Secret Place within.

Set Free

When we know that the truth is truly true and are aware of this truth, we will be set free from all fear.

That we live in the parentheses of eternity, knowing our life is One with God and letting His will be done, is pure bliss!

God lives in us as us. There is no other life but God living as All. We will know the truth, that to be in this world but not of it frees us to live in the Kingdom of God, for He is closer to us than our own breath.

We live in His paradise filled with Love, bathing our souls in pure bliss.

❈ GOLDEN JUNGLE TIGER ❈

❈ MATERNAL LOVE II ❈

His Image and Likeness

HOW WONDERFUL IT IS TO KNOW God loves us enough to give us Life made in His image and likeness.

Life eternal is His gift, perfect in every way.

The invisible splendor expressed as us is our life, when we choose to be at One with Him and let His will be done.

❈ Secret Reef ❈

Letting Go

GOD HOLDS US IN HIS MIGHTY POWER and we are safe from all earthly conditions. It is heavenly to let go and step aside, watching God live in perfect action, perfect order, perfect timing, in the Eternal Now.

To live in His Heavenly Kingdom, we must know ourselves to be spiritual, made of God's substance, in His image and likeness.

Life is eternal, for there's no beginning or end to Spirit. God always was, and He will always be.

God is our Life, therefore we are eternal. This is the truth that sets us free, enabling us to live in His Heavenly Kingdom. Paradise awaits us when we are consciously aware of Him, the Divine Presence, within our consciousness.

❈ Escape ❈

44
God's Touch

TO FEEL GOD'S TOUCH is a bliss beyond human understanding. The Love felt is heavenly. The cup we offer in humble gratitude runs over with living waters of compassion.

✤ Guiding Light ✤

Our Eternal Life

GOD IS ALL LIFE and His Divine Life is Eternal. God lives as us when we let His will be done as our will.

There is never a time when Life is not living; therefore, in truth, Life never ceases to be. We are made in His image and likeness, alive in every moment.

We may change our robes of mortality, to don the robes of Perfection in the Eternal Now of this moment, for all Eternity.

❈ Heaven's Path ❈

Thank You, Father

THANK YOU, FATHER GOD, for your beautiful creations. Oh, how wonderful it is to know You! Thank You, God, for creating us in your image and likeness. We gratefully bow before You, for all your infinite splendor.

Your gift of Life Eternal is so precious. You shower us with your love when we let You live as us. Thank You, wondrous One.

※ SEEKING THE LIGHT ※

The Truth of Being

GOD FILLS ALL SPACE WITH HIS ALLNESS and there is no place where God is not. His Kingdom is everywhere present. God is spirit and we are spiritual beings, made at One with all that God is!

In truth, we never left His Kingdom, for there is no place to live outside of Heaven. We thought or dreamt we were separate from God. However, we need to wake up to the truth that frees us, knowing our Oneness with God has always been!

❈ Maui Daybreak 2001 ❈

God's Everlasting Kingdom

Everywhere I look, I see God in all His beautiful creations. The birds sing of His glory. I feel His presence in the movement of the wind. I hear Him speaking in the stillness of my thoughts, telling me "I am All in All."

Everywhere I look, I see God's presence. His majesty is expressed in the mountains. His infinite splendor is expressed in all space. The moon and stars shine because of His glory. All life feels His presence. In this Eternal Now is God's everlasting kingdom. I feel His peace when I know God is All.

WINDSWEPT

The Fourth Dimension

GOD LIVES WITHIN OUR CONSCIOUSNESS as our Life. He has always lived as us, throughout all eternity.

The Spirit of God, the Christ, waits within our consciousness for us to recognize this truth. He waits for us to invite Him in and live our life for us. God is "All in All." We need to stop believing we have a life separate from God. It is not God and us, it is God as us, for we are One. We are told to listen for "that still small voice" within. To put off "the mortal man and put on the immortal" is the "truth that sets us free."

As we practice these truths, our lives become more harmonious. We will feel the peace that is of God. We feel safe knowing God lives, not I. Therefore, there is no death, for God is eternal and since He is our Life, we are eternal.

Doors open before we ask, all things needed are provided for us. "The government is upon His shoulders." We need to stand aside and watch God in action.

By His Grace we are set free, to live in the Eternal Now, at One with God as our Life is the truth of all being, the fourth dimension.

ENFANTINO PUBLISHING proudly presents quotes and antidotes from the great living artists of today. Take a step into the minds and the philosophy of these great artists and see how their works of art come to life on canvas. For a list of the artists that we feature, check our website at:

www.enfantinopublishing.com